EDGES OF BOOKS

EDGES OF BOOKS

SPECIMENS OF EDGE DECORATION FROM RIT CARY GRAPHIC ARTS COLLECTION

STEVEN K. GALBRAITH

RIT PRESS
ROCHESTER, NEW YORK

RIT Press
90 Lomb Memorial Drive
Rochester, New York 14623-5604
http://ritpress.rit.edu

Cover image: Specimens of fore-edge decoration from the Cary Collection
Designed by Marnie Soom

Printed in the U.S.A.
ISBN 978-1-933360-69-0

Second printing, 2019

Library of Congress Cataloging-in-Publication Data

Melbert B. Cary, Jr. Graphic Arts Collection.
 Edges of books : specimens of edge decoration from RIT Cary Graphic Arts Collection /
Steven K. Galbraith.
 pages cm
 "The Edges of Books" exhibition was shown at the Cary Graphic Arts Collection, Rochester
Institute of Technology from October through December 2012.
 Includes bibliographical references.
 ISBN 978-1-933360-69-0 (alk. paper)
1. Fore-edge painting—Exhibitions. 2. Cary, Melbert Brinckerhoff, 1892-1941—Art collections—
Exhibitions. 3. Melbert B. Cary, Jr. Graphic Arts Collection—Exhibitions. I. Galbraith, Steven
Kenneth. II. Title.
 ND2370.M45 2012
 751.7—dc23
 2012031318

CONTENTS

CELEBRATING THE EDGES

From October to December 2012, the Cary Graphic Arts Collection at Rochester Institute of Technology examines books from an unusual perspective. When books are on display it is usually their spines and covers, or the text and illustrations, that are featured. These are the familiar parts of the books, the parts that modern readers have come to interact with the most. The Cary Collection exhibition *Edges of Books* takes a different approach, uncovering a tradition that extends back centuries to the very beginning of the codex book in which the edges of books were important sites for information and decoration.

A DIFFERENT WAY OF LOOKING AT BOOKS

There are many ways to browse a bookshelf. Typically we are presented with rows of books shelved vertically with their spines out. Thus, we read the titles or names of authors displayed on the spines. In a circulating library, we might scan the call numbers printed on labels placed toward the bottoms of the spines. This information then leads us to the front and back covers of a book, where we find a full title, cover illustration, blurbs supplied by the publisher, laudatory reviews, and maybe even a picture of the author.

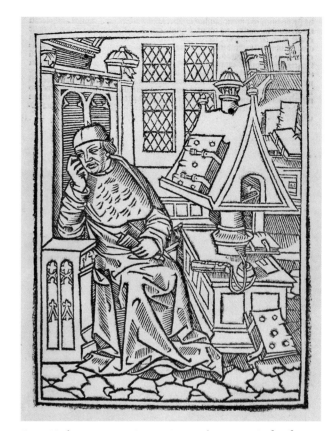

Expositio hymnorum totius anni secundum vsum Sar[um] diligentissime recognitorum multis elucidationibus aucta. London: Wynken de Worde, 1517.

Spines and covers—that's what modern readers are accustomed to navigating and so that's where publishers put all the information and decoration that might lure us into reading the book.

Having spent considerable time in rare book libraries, I have picked up new bibliographic habits that have changed the way that I interact with books. One helpful habit while browsing in book stacks is that I sometimes peer over the spines of the books to their tops or head-edges. Moreover, if I am working in rows of shelves, I often look beyond the spines facing me through to the rows of fore-edges of the books on the shelves behind. In this way, I am browsing the edges of books; that is, the paper edges found opposite the spine and on the top and bottom of books. In book terminology these are called the fore-edge, head-edge, and tail-edge.

EDGES OUT

By browsing the edges of books, I am, in fact, interacting with books in a fashion similar to the way readers would have done so centuries ago when books were not usually shelved vertically with their spines out. Surviving illustrations from the Middle Ages and early modern Europe in the form of paintings, drawings, and woodcut and copper engravings show books shelved in their natural habitats. Rarely are spines facing readers as they do today.

For example, the books found in a woodcut illustration of a scholar in his study from Wynken de Worde's 1517 edition of *Expositio hymnorum* are shelved both vertically and horizontally but the spines are not really seen (page 1). Clearly visible are the front boards (some with metal bosses) and the fore-edges, which are identified by the presence of clasps connecting the boards.

Similarly, the four books found in Albrecht Dürer's 1514 engraving of St. Jerome's study are not shelved spine out. Rather, the books are placed with their edges facing out.

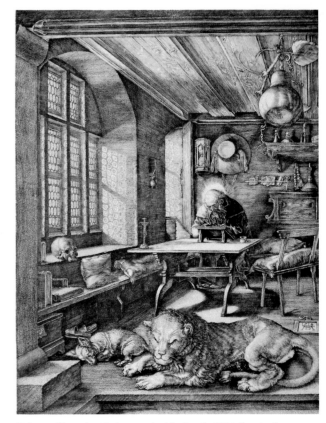

Dürer, Albrecht. *St. Jerome in His Study*. 1514, facsimile. Berlin: Reichsdruckerei, c. 1900.

Up through the sixteenth century, shelving books with their edges facing out was the more common way of shelving books. Personal libraries typically consisted of relatively few books, enough to be stored in a chest or on one or two shelves. If they were stored on shelves, they might be stacked horizontally with one of their edges facing out. Shelving books vertically is a space-saving technique that was not needed for handfuls of books, which lay more naturally on their front or back boards. Also, modern readers have grown so accustomed to seeing information on spines, that the simplicity of putting information on other edges may escape us. After all, isn't it more natural and practical to inscribe information on the vellum or paper edges rather than on the leather or vellum binding on the spine?

The evolution of how books were stored on shelves can be observed through the evolution of illustrations found in editions of Johann Amos Comenius's *Orbis sensualium pictus* or *The Visible World in Pictures* (Petroski 150; Pollard 92-93). First published in 1659 "for the use of young Latin scholars," this picture book teaches Latin by depicting everyday scenes and labeling the objects found within in both English and Latin. A few of the illustrations show books on shelves, including the depiction of a student's "Study" or, in Latin, "Museum." In the early editions, the books on the shelves are shown fore-edge out, as indicated by vertical lines suggesting the edges of the boards and the pages of the text block (top right). *Orbis sensualium pictus* went through many editions. When the illustrations were re-engraved sometime in the eighteenth century, the books in the study were drawn to reflect the more modern practice of shelving books with their spines facing out, as indicated by horizontal lines suggesting the sewing bands (bottom right). As *Orbis sensualium pictus* went from edition to edition, habits of shelving books changed. This small update in the illustration of the "Study" illustrates this change.

Shelving books fore-edge or head-edge out was also a practice connected to chained libraries. In monasteries, universities, guilds, or wherever books might be made available to multiple readers, books would often be chained to the desks or

Comenius, Johann Amos. *Orbis sensualium pictus*... London: printed for, and sold by John Sprint, 1705.

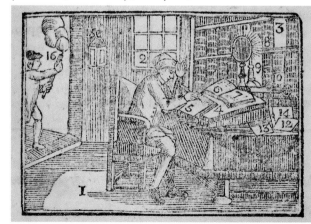

Comenius, Johann Amos. *Orbis sensualium pictus*... London: Printed for S. Leacroft, 1777.

3

shelves to ensure that none would go missing. The most sensible place to attach a chain to a book was on the upper or mid fore-edge of one of the boards. The book was then placed on the shelf with the fore-edge or head-edge facing out, so that the chain rested in front of the book rather than looping awkwardly around or over the book to the back.

INFORMATION ON EDGES

Because it was the edges of books that faced potential readers, edges became sites for book owners to write important information. Most often they wrote the book's author or title. For example, a copy of *Plutarchi cheronei Græcorum Romanorumque illustrium vitae* (Plutarch's *Lives of the Noble Greeks and Romans*) printed in Basil in 1553 survives in the Cary Collection with its author's name and abbreviated title inscribed in ink on the top of the book's fore-edge: "Plutarchi Illustri Vitae" (page 14). An early owner wrote this bibliographic information on the fore-edge in order to make the book identifiable without being opened. It's safe to say that this book was shelved vertically with its fore-edge out. In this way, information inscribed on the edge of a book helps provide important clues regarding the book's history, its early owners, and how it was stored.

Other important information often survives on the edges of early books. Occasionally the name or initials of a book's owner are inscribed onto an edge. The Cary Collection's copy of a 1518 edition of the orations of Marcus Fabius Quintilianus has the letters "T:W." inscribed on its head edge (page 17). These are most likely the initials of the owner of the book.

In modern libraries you usually find a book's call number or shelfmark at the tail of its spine, but in the earliest libraries, books might have shelfmarks written on their fore-edges, such as the one found on an edition of Cicero from 1551 held at the Cary Collection (page 18). Though now faded, it looks like the number "13" was written on its fore-edge to indicate its location on a shelf.

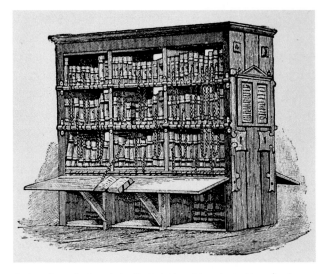

A drawing of a bookshelf of chained books in Hereford Cathedral Library.

4

Unfortunately, a great deal of information that was recorded on the fore-edges of books has been lost. Obviously, it is the case that only a percentage of books from the first centuries of printing have actually survived, but this is compounded by the practice of trimming the text block of a book each time that it is rebound. As time passes, bindings deteriorate, fashions change, and books change hands. Thus a book may have occasion to be rebound several times in its lifetime. Each time a book is rebound, the binder trims the book's edges, because after the process of resewing the gatherings back together, the leaves do not always line up evenly. A new, even surface is created by trimming the edges by a few millimeters. Consequently, if anything is written on the edges, it will be removed too.

Rather than writing on the edges of a book, an alternative option for providing information is to use an edge label. Information about the book is written or printed on a slip of paper that is pasted onto the front board and folded in such a way that it can either hang over an edge or fold back into the book. The Cary Collection recently acquired two examples of edge labels, one manuscript and one printed (page 19).

Using fore-edges to convey information is not just a thing of the past. Modern books still provide information and navigational tools on their fore-edges. Dictionaries, for examples, have thumb indexes carved into the fore-edges, allowing readers to open the book to the letter for which they are looking. It's a simple feature, the utility of which is easy to overlook. Naturally, RIT's Wallace Library owns numerous dictionaries with thumb indexes, but for the exhibition we chose to display a catalog from the Mergenthaler Linotype Company that uses a thumb index to help readers find typefaces (page 20).

DECORATION ON EDGES

In addition to being conveyors of important information, the edges of books are often sites of beautiful decoration. Beginning in the fifteenth century, the most common edge decoration has been gilded edges (Greenfield 33; Marks 39). Gold, being very malleable, is beat into very thin sheets ("to airy thinness beat" as John Donne put it in "A Valediction: Forbidding Mourning"). The gold is then applied to the book's edges using an adhesive size that is often made of egg white and water. Gilding was not simply decorative. In addition to giving the edges a beautiful golden luster, the gold creates a metal layer that protects the paper (or vellum) from dust and moisture (page 23).

Gilt edges are usually splendid enough, but some have an extra decorative flourish. Gauffering is the process through which decorative patterns are impressed into the gilt edges by using heated binder's finishing tools (see pages 24-25). Typically patterns are created one small dot at a time in the pointillé style, creating detailed and elaborate designs. Words may also be gauffered into the gilt edges. For example, the Cary Collection has a volume of poetry titled *The Book of the Poets* (1850) with the words "The Poets" gauffered on the fore-edge and "Poets" on the head and tail-edges (page 62).

A tradition of fore-edge decoration that predates gilt edges and still survives today is colored edges. If you only look at the spines of centuries-old books, you'll see traditional vellum and tanned leather. If you look at their edges, however, they sometimes take on Technicolored personalities more reminiscent of Apple's first iMacs than of early books. Dating back as far as the fourth century, books were colored by brushing dyes and pigments onto their edges (Mitchell 23; Marks 38). Although red was by far the most common color, books found in the Cary Collection have fore-edges colored in yellow, green, shades of blue, and even an orangey-pink (pages 26-28). As with gilding, staining the edges of a book produces a layer that shields the paper.

KEEPING IT NATURAL

The simplest decoration on a fore-edge isn't really a decoration at all. When hand-made, laid paper is produced, the loose pulp is held in place on a paper mold by a frame called a deckle. The pulp does not spread evenly around the frame and sometimes slides beneath it. Thus when the paper dries, the edges do not come out straight, but rather rough and uneven. Edges in this uneven, pre-trimmed state are referred to as deckle edges. Only after the text block is cut or significantly trimmed do the edges of a book made with laid paper have the smooth surfaces to which modern readers have grown accustomed.

A deckle edge is an edge in its natural form and it can often be quite beautiful. The Cary Collection's copy of William Morris's edition of the *Golden Legend* retains its deckle edge, but probably due to the wishes of its owner rather than of Morris (page 34). On a slip now pasted onto the book's front paste-down leaf are instructions to future owners of the book: "IF this book be bound the edges of the leaves should only be TRIMMED, not cut" (page 35). For Morris, trimming off the deckle edges is fine, but do not cut into the book's ample margins.

OVERHANGING EDGES OR YAPP BINDINGS

In the sixteenth and seventeenth centuries, books bound in vellum might have an added feature that served to protect the book's edges. Rather than having the vellum simply wrap around the fore-edges of the boards, the vellum was made to extend out, so that the edges of the binding hung over the edge of the text block at about a 90 degree angle or so (page 36). When the book was closed these overhanging edges created a protective enclosure that covered the book's edges. Some are quite dramatic, with the vellum edges meeting each other halfway, completely obscuring the paper edges when shut. In the mid-nineteenth century, a London bookbinder named William Yapp began making leather bindings designed in a similar fashion to the earlier overhanging vellum bindings. Thus the

term "Yapp" edge has come to be used generically for the edges of binding that hang over the edges of books.

FORE-EDGE PAINTINGS

The edges of books are also canvases for works of art. For centuries painting on the edges of books has been a way of beautifying them. A recent auction at Christie's, for example, featured a number of books from Italy's Pillone Library with colorful fore-edge paintings from the late sixteenth century by Cesare Vecellio. These paintings are mostly of the books' authors and of other illustrative subjects that allude to the contents inside (Weber 222). Profile portraits of historical figures are well suited for the thin vertical surface of the fore-edge.

The oldest fore-edge painting in the Cary Collection appears to be a floral garland with ribbons on either end found on a 1745 edition of *The Book of Common Prayer* (page 38). The painting appears to be contemporaneous with the book's mid-eighteenth century decorative binding featuring a wheel motif with the crucifixion at the center. Some of the fore-edge painting appears to have been rubbed away over the years. Or it might be the case that this painting was once hidden under a gilt layer, a playful fore-edge decoration technique that dates back as early as the mid-seventeenth century (Marks 39).

HIDDEN FORE-EDGE PAINTINGS

The term "fore-edge painting" could mean any painting applied to the fore-edge of a book, but over the last century it has become more synonymous with a style of fore-edge painting in which a painting is hidden under a layer of gilt and revealed only when the pages of the book are fanned. Revealing the painting can be quite surprising. Any librarian or curator who has shown fore-edge paintings to those unfamiliar with this artistic genre can attest to the amazement and delight that the unexpected appearance of a painting can bring. Hidden fore-edge paintings never

fail to charm visitors to the Cary Collection.

Hidden fore-edge paintings appear to increase in popularity in the mid-eighteenth century, but a real vogue began much later. According to Jeff Weber,

> The "Golden age" of fore-edge painting is romantically placed in the period of the Edwards of Halifax (1755-1826) and those that soon followed them. However the real zenith of fore-edge painting production was during the early twentieth-century, even extending to the present, when a vast number of specimens were created. (21)

Even today, fore-edge painters such as Martin Frost are keeping the tradition alive (http://www.foredgefrost.co.uk/).

The process of creating a fore-edge painting begins by placing a book into a clamp with its pages fanned. A painting is applied to the surface of the fanned pages. When the painting is dry, the book is shut and a layer of gold is applied onto the book's edges, thus hiding the painting. When the book is shut, all that is visible is the gold. When the pages are fanned, the painting appears.

The pages of a book fan in two directions, of course, so it is possible to paint two illustrations onto one fore-edge. After the first painting is finished, the pages are fanned in the opposite direction and clamped. A second painting is applied to this surface. Now when a layer of gilt is applied onto the fore-edge, it covers not one, but two paintings (see pages 40-41, 52-53, 56-57). This description simplifies things quite a bit. For step-by-step instructions see Jeanne Bennett's *Hidden Treasures: the History and Technique of Fore-edge Painting* (Granbury, TX: Calliope Press 2012).

THE SUBJECTS OF FORE-EDGE PAINTINGS
The Cary Collection holds over 100 books with fore-edge paintings. The resounding

majority of these paintings are landscapes showing pastoral subjects such as wintery scenes, people hunting and fishing, or trains traveling the countryside (pages 40-45, 59-61). Cityscapes spotlighting famous places in the world are also popular subjects, including sites such as Windsor Castle, Jerusalem, the Taj Mahal, and the Basilica of Saint Peter (pages 46-54).

Landscapes and cityscapes are a good match for a fore-edge's horizontal canvas. Vertical paintings are much more rare. Demonstrating this point, of all the hundred plus fore-edge paintings in the Cary Collection, only one is a full vertical painting. The book is Samuel Rogers' *Italy, a Poem* (1830) and the painting depicts the Bridge of Sighs in Venice, called thus because it was the bridge that led prisoners from the Doge's Palace to the city's prisons (page 48). A longstanding legend maintains that if you kiss your significant other under the bridge, you will have eternal love.

A painting of the Bridge of Sighs perfectly befits a poem on Italy and, in fact, Rogers mentions the bridge in his poem. Indeed, for the most part, the subject matter of fore-edge paintings evokes the subject matter of their books. For example, the Cary Collection's 1823 copy of Izaak Walton's perennially popular fishing book, *The Compleat Angler*, could only feature a fore-edge painting of a pastoral fishing scene (page 42). Similarly, it was an apt choice to adorn the fore-edge of a 1743 edition of the *Book of Common Prayer* with a triptych of scenes from outside and inside England's Westminster Abbey (page 64).

Yet sometimes, the subject matter of the fore-edge painting does not correspond with the subject matter of its book, and the outcomes can be unexpected and charming. For example, an 1868 edition of Alfred Tennyson's *Idylls of the King* held at the Cary Collection is adorned with a double fore-edge painting. Imagine my surprise to find that its edges had been decorated with a painting of the White House and of a view of the United States Capitol Building as seen from across the Potomac River in Alexandria, VA (pages 52-53).

But most often, the choices of subject make perfect sense. The Cary Collection owns an 1855 edition of the *Poems of William Shakespeare* with a fore-edge painting of Shakespeare's birthplace (page 55). Similarly, an edition of *The Poetical Works of Robert Burns* from 1821 features a double fore-edge painting. Fan the pages to the right and you see the clay cottage where Burns was born in Alloway, Ayrshire, Scotland. Fan the pages to the left and you will see Struthers Steps, Kilmarnock (pages 56-57).

One of the most delightful fore-edge paintings in the Cary Collection is found on volume one of the collected works of the English poet William Cowper (1731–1800). Cowper was known for spending time in his garden at Orchard Side in Olney, Buckinghamshire. Keeping him company were three rabbits: Puss, Tiney, and Bess, who were given to him by his neighbors. These rabbits not only make appearances in Cowper's literary work, but also on a fore-edge painting. Volume one of the collected works has a painting depicting Cowper working in his garden while one of his rabbits (it's hard to say which one) looks on (page 58).

As fore-edge paintings became more popular, certain bookbinderies became well known for their work. From the mid-eighteenth century through the early-nineteenth century, the Fazakerley Bindery of Liverpool, England was one of those binderies. Fazakerley bindings often feature a fore-edge with a visible painted triptych surrounded by elaborate gauffered designs. A collection of Annual Reports of Victoria Hospital, Blackpool now held at the Cary Collection has a Fazakerley binding in this style (page 39). The book came to the Cary through the collection of the renowned bookbinder Bernard Middleton. This extraordinary Fazakerley fore-edge manifests many of the styles of fore-edge decoration discussed above, a dynamic combination of gilt edges, gauffering, and painting that foretells the book's contents.

THE EDGES OF BOOKS

As the nature of books has evolved, the ways in which readers interact with them have evolved as well (and continue to evolve). There is no doubt that spines and covers are the places where readers now look first for quick information about books. Indeed, readers have regularly interacted with spines of books for centuries now. These areas of a book's binding can be as beautiful and extraordinary as their designers' imaginations allow.

The books shown in this exhibition remind us, however, of the great possibilities found in the edges of books. This is manifested not only in splendid decoration that beautifies books as objects of art, but also in the ways that edges interact with readers, supplying them with information and helping them navigate a book.

I hope that the Cary Collection exhibition *Edges of Books* inspires you to interact with books in new ways, or at least be aware of the different ways that a book is inviting you to interact with it. I hope book designers find some inspiration from a long history of treating a book's edges as a canvas for a great many forms of decoration. I know that the process of putting this exhibition together has reminded me of how books continue to surprise and excite. As I looked at the *Edges of Books*, I felt like I was seeing the Cary Collection anew.

Steven K. Galbraith
Rochester, New York
October 2012

EDGES OF BOOKS

INFORMATION ON EDGES

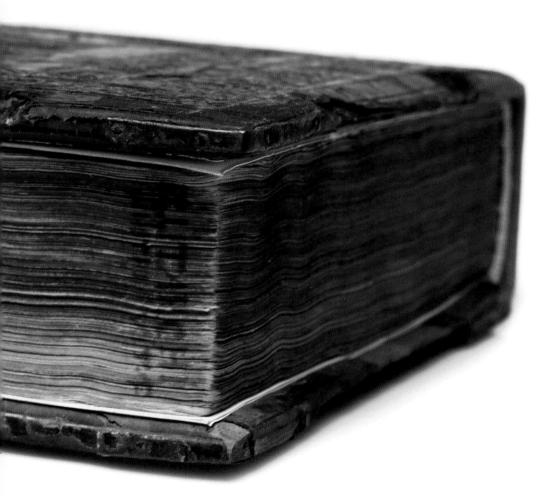

An abbreviated title reading "Plutarchi Illustri Vitae" or "The lives of the Illustrious Plutarch," appears at the top of the book's fore-edge suggesting that it once rested vertically on a shelf with its fore-edge out.

Plutarchi cheronei Græcorum Romanorumque illustrium vitae. Basileae: Apud Mich. Isingrinium, 1553.

The title inscribed on the tail-edge of this book reads
"Test. Vetus," abbreviated Latin for "Old Testament."

Biblia Sacra Veteris et Novi Testamenti ivxta Vvlgatam aeditio-
nem. Parisiis: Apud Iacobum Keruer, 1562.

A red-orange stained edge partially obscures the inscription "Archimed Opera Cum Com," abbreviated Latin for the book's title "The Work of Archimedes with Commentary."

Archimedes. *Opera non nvlla a Federico Commandino vrbinate nvper in latinvm conversa, et commentariis illvstrata.* Venetiis: apud Paulum Manutium Aldi F., 1558.

16

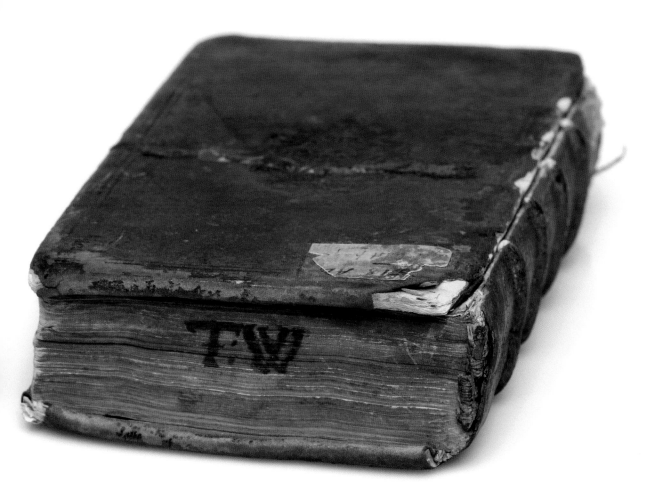

The "T:W" inscribed on the head-edge of this copy of the orations of Quintilian are most likely the initials of an early owner of the book.

Marci Fabii Qvintiliani oratoriarum institutionum libri duodecim diligenter emendati. [S.l.] : [s.n.], 1518.

In the center of the fore-edge of this sixteenth-century edition of Cicero appears to be the number "13," likely a shelf-mark indicating where the book used to rest in an early library.

Marcus Tullius Cicero. *In omnes de arte rhetorica M. Tullij Ciceronis libros, item in eos ad C. Herennium scriptos, doctissimorum uirorum commentaria.* Venetijs. [Aldus], MDLI [1551].

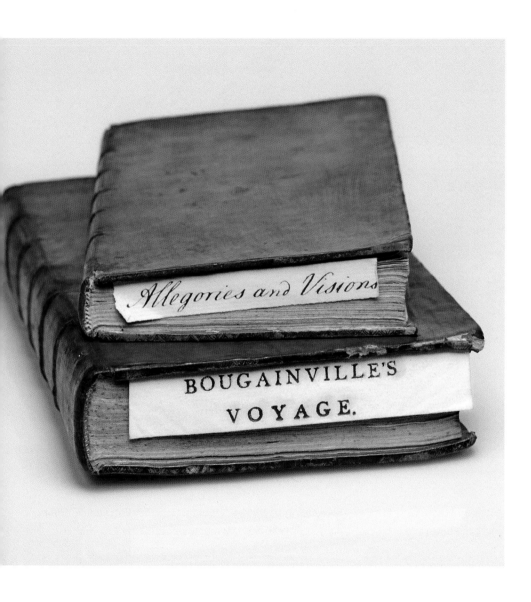

An alternative to writing the author or title onto one of a book's edges is to write or print the information on a folding edge label that is then affixed to the front or back board. When unfolded the label covers the edge of the book, as shown in these examples. When folded the label disappears back into the book.

Allegories and Visions, for the Entertainment and Instruction of Younger Minds, Selected from the Most Eminent Authors. London: printed for George Pearch..., 1769.

Bougainville, (Lewis De). Forster, John Reinhold. *A Voyage Round the World Performed by Order of His Most Christian Majesty, In the Years 1766, 1767, 1768 and 1769.* Dublin: J. Exshaw, H. Saunders, J. Potts et al 1772.

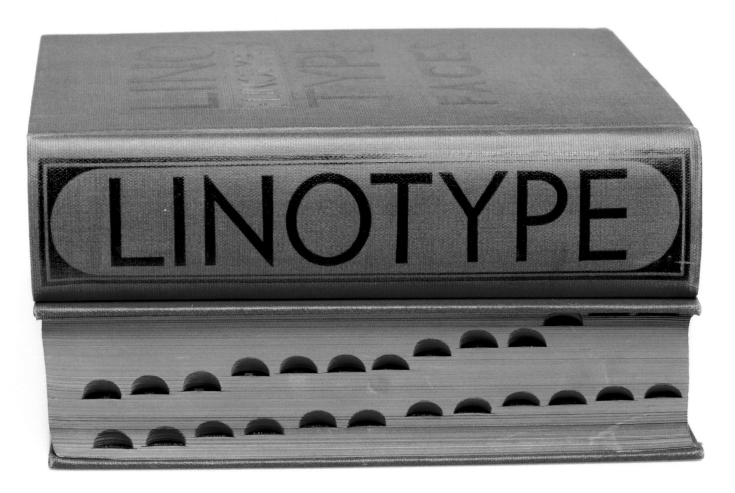

Typically found on large dictionaries, thumb-indexes help readers quickly find the section of the book they need. In the case of this Linotype manual, readers can thumb to a specific typeface.

Specimen book Linotype Faces by Mergenthaler Linotype Company. Brooklyn, N.Y.: Mergenthaler Linotype Co., [n.d.].

The use of fore-edge tabs dates back to medieval manu-script books when leather tabs were applied to the edges of leaves. These modern colorful tabs bring the reader to type available from the Rochester Typographic Service.

Type Faces: For your Advertisements, Folders, Catalogs, Books and Broadsides. Rochester, N.Y.: Rochester Typographic Service, [between 1947 and 1957].

GILT EDGES

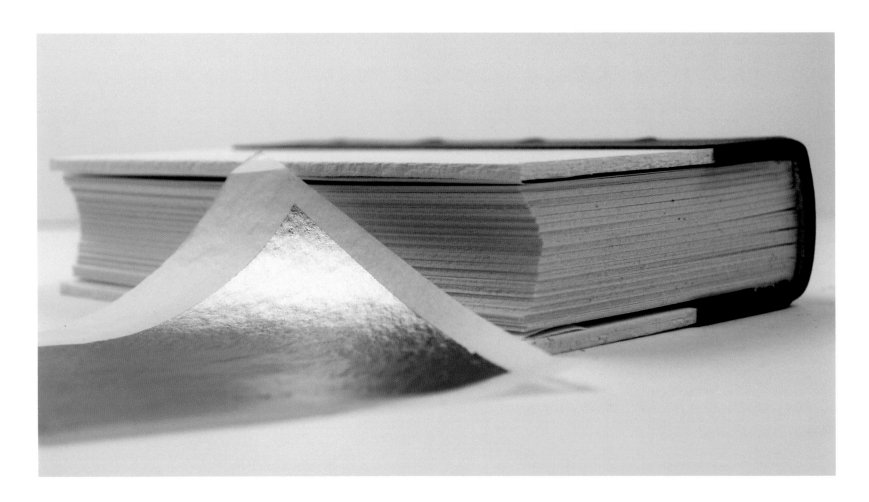

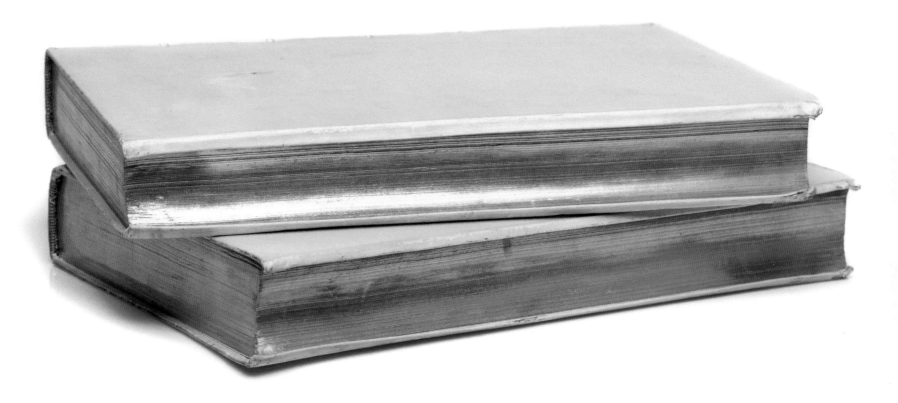

Gilding edges is one of the most traditional ways of beautifying a book. The long edges of these sixteenth-century volumes of Pliny were gilded when they were rebound centuries later and have not lost their shine.

Pliny, the Elder. *L'Histoire dv monde de C. Pline... collationnée & corrigée sur plusieurs vieux exemplaires...* Lyon: Claude Senneton, 1566.

GAUFFERED EDGES

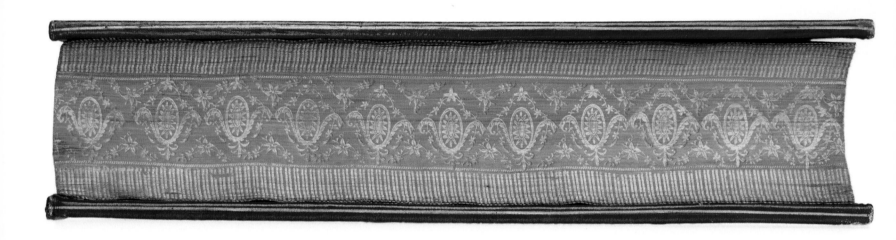

Gauffering is the process through which designs are created on gilt edges using heated binder's tools, often dot-by-dot in the pointillé style. This beautiful gauffered edge dramatically shows the contrast between the burnished gilt and the paper edge where the gold has been removed.

Milton, John. *Paradise Lost. A Poem, in Twelve Books.* Birmingham: Printed by J. Baskerville for J. and R. Tonson in London, 1759.

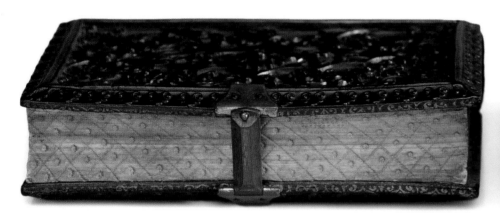

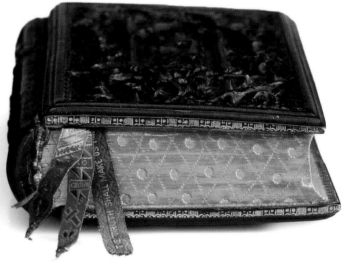

These gauffered edges adorn papier mâché binding specimens found in the Bernard C. Middleton Collection at the Cary Collection. The silk bookmarks read "Faith Hope and Charity", "No Cross No Crown" and "The Truth Shall Make Us Free."

The Book of Common Prayer. Oxford [England]: University Press; London: Sold by E. Gardner and by G.B. Whittaker; Derby: Also by H. Mozley and sons, 1844.

The Holy Bible: Containing the Old and New Testaments. Edinburgh: Printed by Sir D. Hunter Blair and M. S. Tyndall Bruce, 1843.

STAINED OR COLORED EDGES

This book stack, and the one following, show the variety of colors used to stain the edges of books.

Tuckerman, Henry T. *Leaves From the Diary of a Dreamer. Found Among his Papers.* London: W. Pickering, 1853.

Burke, Edmund. *A Philosophical Enquiry into the Origin of our Ideas of the Sublime and Beautiful.* London: Printed for J. Dodsley, 1767.

Arte de Escribir por Reglas y con Muestras, Segun la Doctrina de los Mejores Autores Antiguos y Modernos, Extrangeros y Nacionales... Madrid, Impr. de la viuda de don Joaquin Ibarra, 1798.

The Holy Bible, an Exact Reprint in Roman Type, Page for Page of the Authorized Version Published in the Year 1611. Oxford: Printed at the University Press, 1911.

Virgil. P. *Virgilii Maronis, poetae mantvani, vniversvm poema.* Venetiis: apud Ioannem Gry-
phium, 1584.

Archimedes. *Opera non nvlla a Federico Commandino vrbinate nvper in latinvm conversa, et
commentariis illvstrata.* Venetiis: apud Paulum Manutium Aldi F., 1558.

Marcus Tullius Cicero. *Le lettere familiari Latine di M.T. Cicerone e d'altri avttori...* Venetia:
Appresso gli Heredi di Marchio Sessa, 1620.

Martini Borrhai Stugardiani in tres Aristotelis de arte dicendi libros commentaria. Basileae:
Impensis Ioannis Oporini, 1551.

The blue staining, the ivory-looking alum-tawed pigskin binding, and the remnants of leather clasps give this book the appearance of a much earlier book than one printed in Germany in the early eighteenth century.

Tägliche Erquickung der Seelen, oder Betrachtungen auf alle Täg deß Jahrs. Augspurg: Labhart, 1726. Vols 1 and 2.

While early edge decoration was a unique process that varied from book to book, modern edge decoration is often mechanical and applied to the whole of a print run.

Westminster Press. *Faces, Borders and Ornaments.* [London]: The Westminster Press, [ca. 1930]. Copies 1 and 2.

MARBLED EDGES

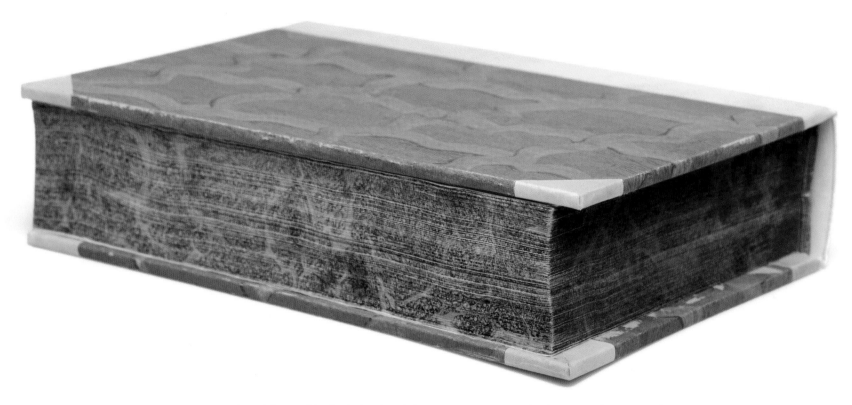

Marbled edges are created by clamping closed the text block of a book and dipping its edges into a bath of colors. This book's thick text block provides a healthy amount of space for marbling its edges.

Rhodiginus, Lodovicus Caelius. *Sicvti antiqvarvm lectionvm commentarios concinnarat olim vindex Ceselivs...* Venetiis: In aedibvs Aldi, et Andreae soceri, Febrvario 1516.

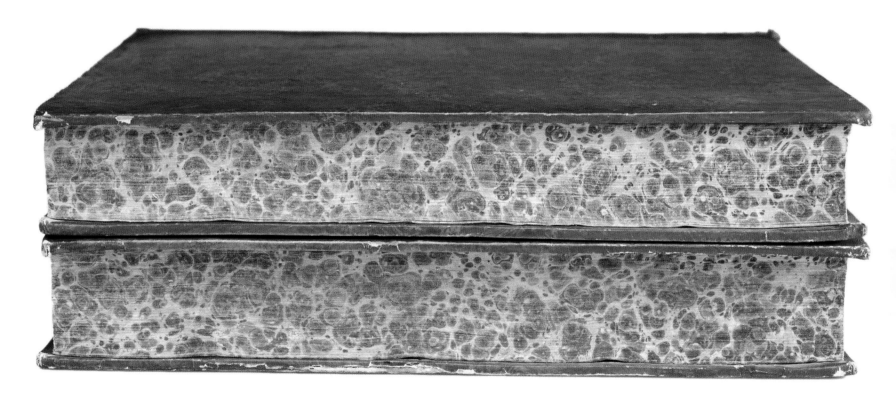

Marbled edges adorn the Cary Collection's copy of the enlarged edition of Giambattista Bodoni's *Manuale tipografico* (1818). Published after his death, this type specimen remains a testament to one of history's most influential type designers.

Bodoni, Giambattista (1740-1813). *Manuale tipografico del calaliere Giambattista Bodoni.* Parma: Presso la vedova, 1818.

MINIATURE BOOKS

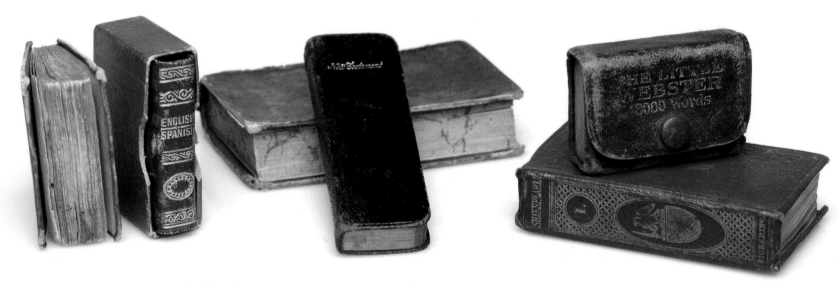

From left: *Dew-drops*. New York: Published by the American Tract Society, [n.d.]

 Lilliput Dictionary: English–Spanish. Leipzig: Schmidt & Günther, 1900. Pickering, 1825. Vol. I.

 Novum Jesu Christi Testamentum vulgatæ editionis juxta exemplar vaticanum, editio accuratissime recognita. Parisiis, Apud Gaume fratres, 1844.

 "The Finger New Testament." *The New Testament of our Lord and Saviour Jesus Christ ...* Oxford: Printed at the University Press ; London : Henry Frowde... , [1908].

 Shakespeare, William. *The Plays of Shakespeare, in Nine Volumes*. London: William Pickering, 1825. Vol. I.

 The Little Webster Liliput Dictionary. Leipzig: Schmidt & Günther, [1935].

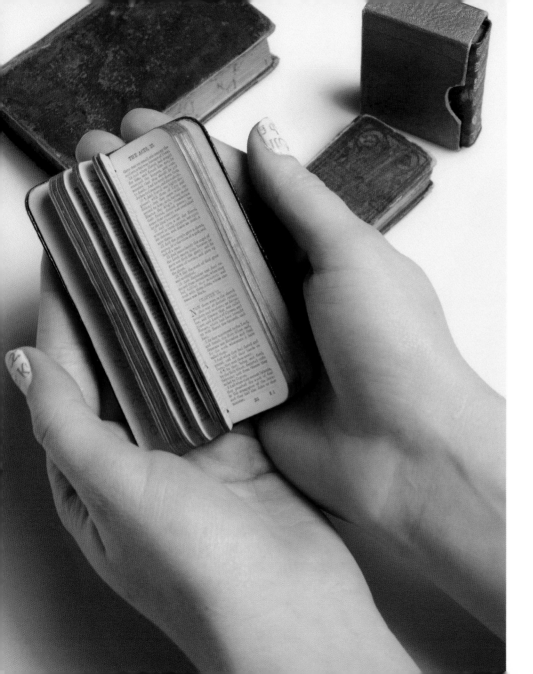

Even the tiny edges of miniature books can be decorated.
Among these books are gilded, marbled, and stained edges.

NATURAL EDGES

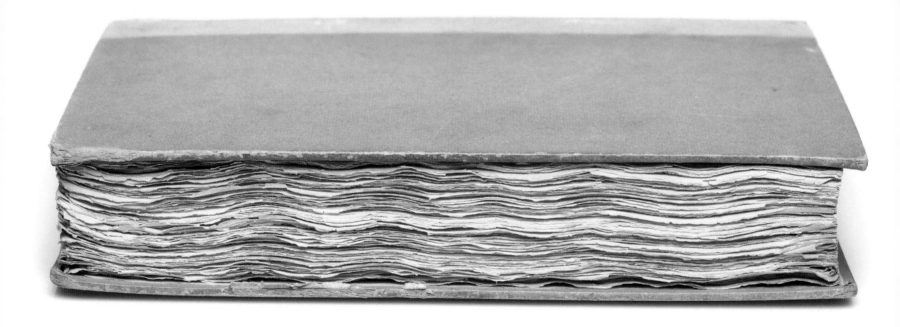

Sometimes the finest decoration a book's edges can have is no decoration at all. The fore-edge of this edition of *The Golden Legend* printed by William Morris retains its deckle fore-edge; that is, the untrimmed, ragged and textured edge of the paper as it originally was when it came out of the mold in which it was made.

The Golden Legend. Hammersmith: Kelmscott Press, 1892.

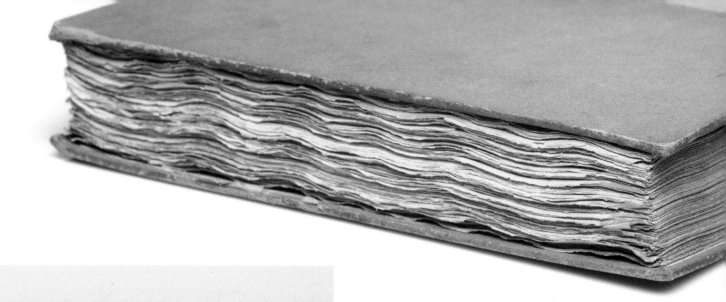

IF this book be bound the edges of the leaves should only be TRIMMED, not cut. In no case should the book be pressed, as that would destroy the "impression" of the type and thus injure the appearance of the printing.

W. MORRIS.

Pasted on the front board of volume one of *The Golden Legend* is this note from William Morris demanding the edge be only "TRIMMED, not cut." The book's owner had only the head and tail edges trimmed, retaining a deckled fore-edge.

OVERHANGING EDGES AND CLASPS

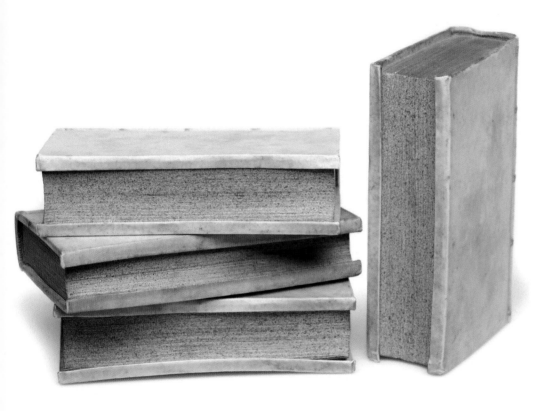

An early owner of these seventeenth-century editions of Ovid's works had them bound in vellum with overhanging edges that protect the fore-edges.

Ovid. *P. Ovidii Nasonis Operum tomus tertius. In quo Fasti, Tristia, Ponticae epistolae, et Ibis.* Amstelaedami, ex officina Elzeviriana, 1661.

Nicolai Heinsii D. F. notae in Metamorphoses P. Ovidii Nasonis. [S.l. : s.n., n.d.]

Nicolai Heinsii D. F. notae in Heroïdas P. Ovidii Nasonis. [S.l. : s.n., n.d.].

Nicolai Heinsii D. F. notae in sex libros Fastorum P. Ovidii Nasonis. [S.l. : s.n., n.d.].

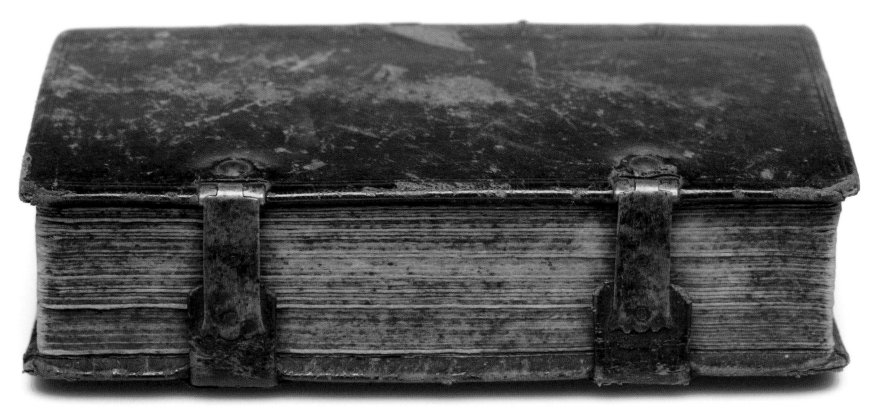

The use of clasps on books dates back to the earliest codices. Affixed to the fore-edges, clasps stabilize a book, preventing the vellum or paper leaves from fanning out and the boards from warping.

Tersteegen, Gerhard. *Geistliche brosamen: von des Herrn tisch gefallen, von guten freunden aufgelesen.* Reading: Jhann Ritter & Co., 1807.

VISIBLE FORE-EDGE PAINTINGS

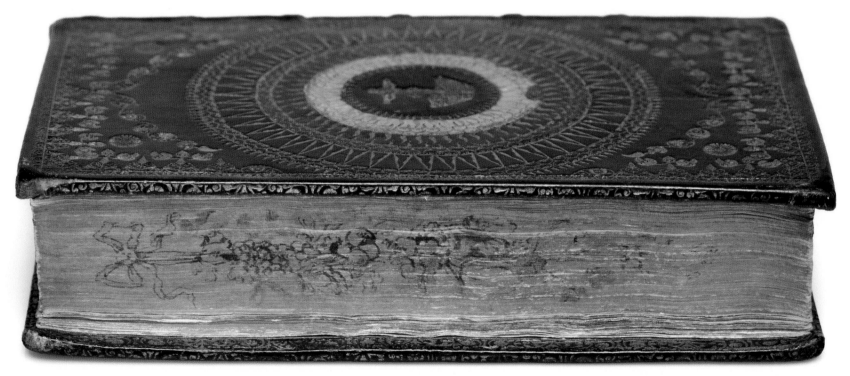

This fore-edge painting appears to be contemporary with its mid-eighteenth-century decorative binding, making it probably the oldest fore-edge painting in the Cary Collection. This is not a hidden fore-edge painting, but is meant to be seen without fanning the pages of the book. The colors of the floral garland and ribbons appear to have worn off after centuries of use.

The Book of Common Prayer. Oxford: Thomas Baskett, 1745.

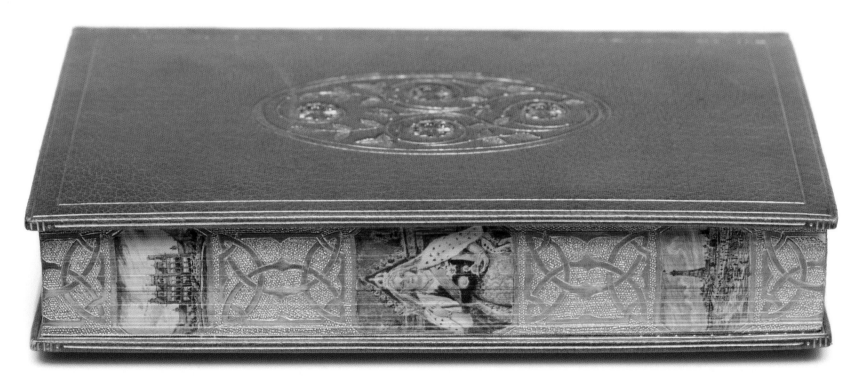

The famous Fazakerley Bindery in Liverpool (1835-1914) produced this superb binding and fore-edge painting. The Fazakerley's often combined triptych paintings with detailed gauffered designs. From the head of the spine to the tail are depicted: Victoria Hospital, Blackpool (based on a photograph found on the title page of several of the annual reports), a portrait of Queen Victoria, and Blackpool Beach.

Annual Reports from the Victoria Hospital, Blackpool, England. [Blackpool: s.n.], 1894-1900.

HIDDEN FORE-EDGE PAINTINGS

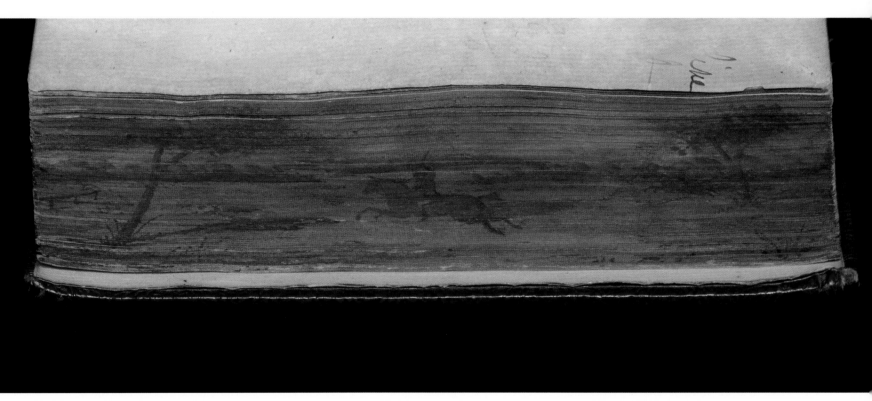

This 1680 Latin edition of the *Book of Common Prayer* was published by Samuel Mearne (1624-1683), who at the time was King Charles II's royal bookbinder. Although specimens of fore-edge paintings by Mearne survive, the double fore-edge painting on this copy was painted at a much later date. The paintings extend onto the book's head and tail-edge.

Church of England. *Liturgia, seu, Liber precum communium, et administrationis*. London: Samuel Mearne, 1680.

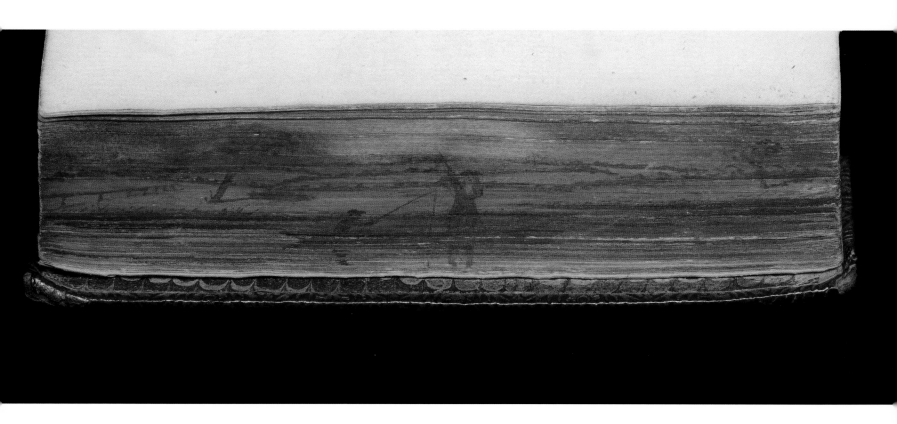

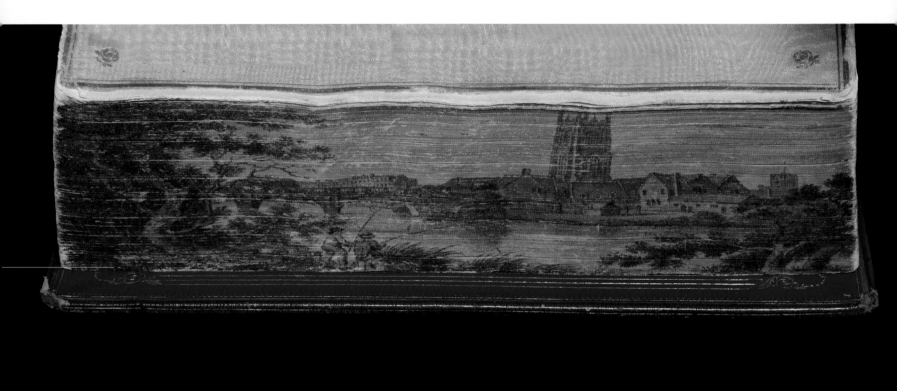

First published in 1653, Walton's book on the art of fishing, *The Compleat Angler,* has enjoyed centuries of popularity and is still in print. Only a fishing scene would really make sense on the fore-edge.

Walton, Izaak. *The Complete Angler of Izaak Walton and Charles Cotton: Extensively Embellished with Engravings on Copper and Wood.* London: John Major, 1823.

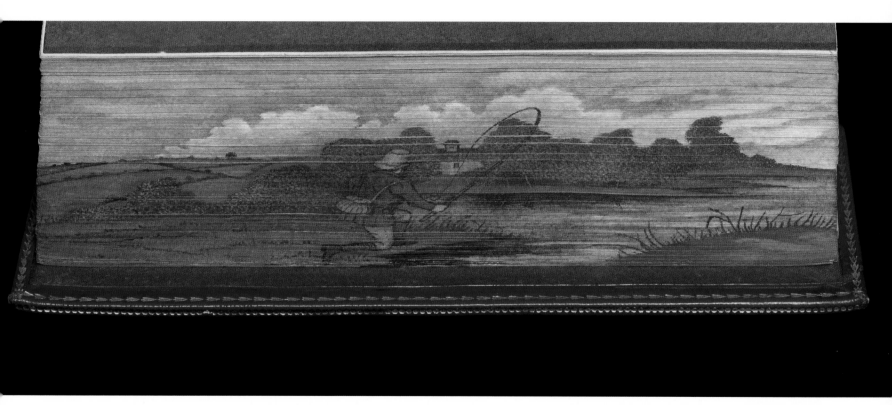

One of the topics covered by Walton's *Compleat Angler* is fly fishing, dramatically shown here on the fore-edge of *The Advantages of Solitude* by the Swiss philosopher Johann Georg Ritter von Zimmermann.

Zimmermann, Johann Georg. *An Examination of the Advantages of Solitude; and of its operations on the heart and mind; with an enquiry into its prejudicial influence on the imagination and passions.* London: James Cundee, 1805. Vol. 2.

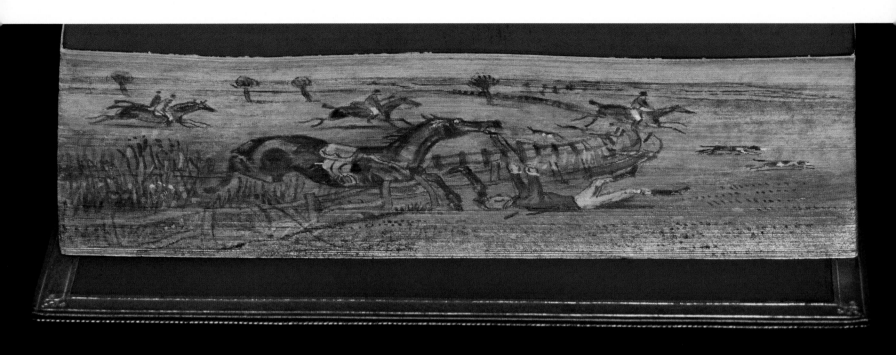

Each of the Cary Collection's three volumes of George Ellis' *Specimens of the Early English Poets* has a fore-edge painting showing a foxhunting scene with some sort of comic mishap. Here a rider has flipped over his horse. Let's hope he wasn't trampled.

Ellis, George. *Specimens of the Early English Poets.* London: Henry Washbourne, 1845. Vol. 2.

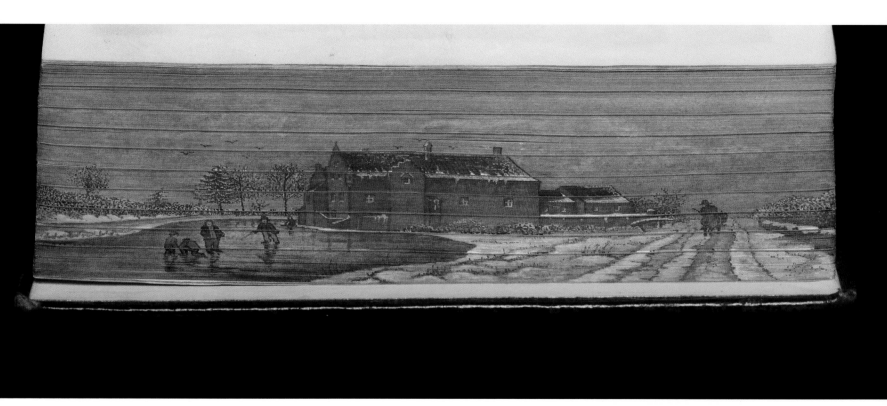

The wintery theme of this "Literary Album and Annual Remembrance" is augmented with a winter scene painted on the book's fore-edge. The lines seen on the fore-edge are caused by the engraved illustrations inserted into the book.

Friendship's Offering and Winter's Wreath: a Christmas and New Year's Present, for MDCCCXXXVII. London: Smith, Elder and Co., 65, Cornhill: and William Jackson, 53, Cedar-Street, New York., 1837.

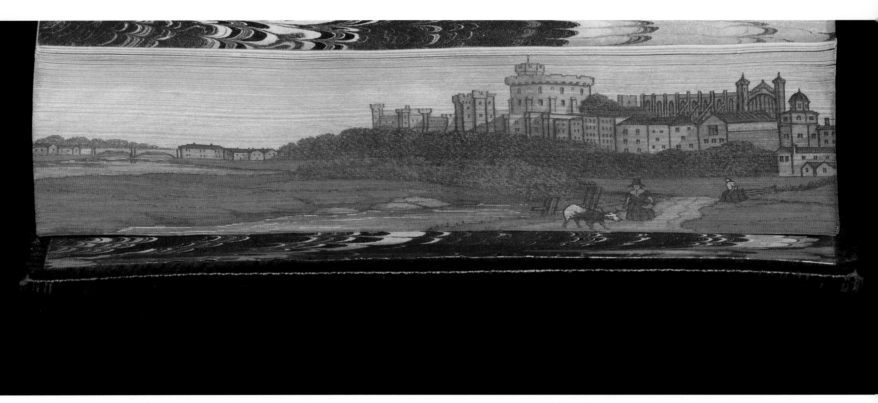

A fore-edge painting of Windsor Castle adorns this edition of John Evelyn's biography of Margaret Blagge Godolphin (1652-1678), a courtier in King Charles II court known for her extraordinary beauty.

Evelyn, John. *The Life of Mrs. Godolphin.* London: William Pickering, 1848.

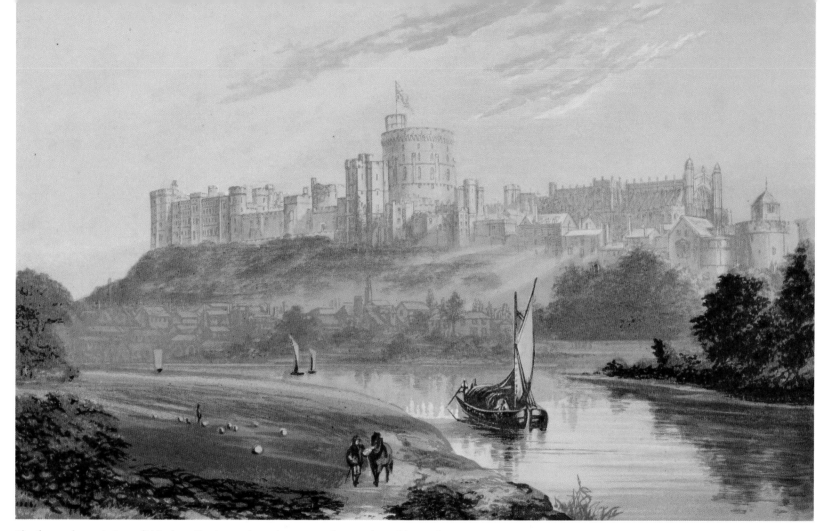

The fore-edge painting of Windsor Castle was based on engravings such as this one from
F. O. Morris' *A Series of Picturesque Views of Seats of the Noblemen and Gentlemen of Great Britain and Ireland* (London: William Mackenzie, 1880).

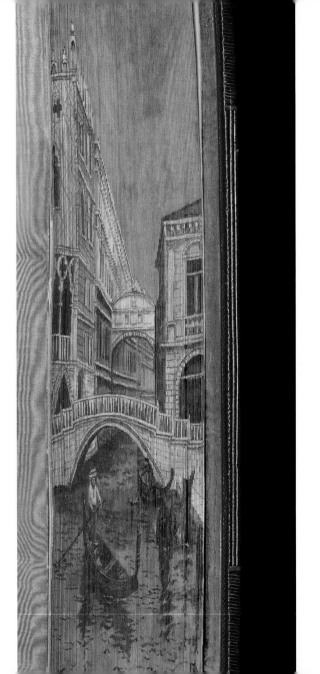

The white, enclosed arch found in the center of this fore-edge painting is the Bridge of Sighs in Venice. It was named thus by Lord Byron because it led prisoners from Doge's Palace to the prisons. Legend has it that if you kiss your significant other under the bridge, you will have eternal love.

Rogers, Samuel. *Italy, a Poem*. London: T.Cadell, Strand; Jennings and Chaplin, 1830.

A view of Jerusalem from the Mount of Olives, an important site in both the Old and New Testaments. The blue-domed building just left of center is the Dome of the Rock.

The Connexion of the Old and New Testament; Or, The History of the Jews, from the Close of the Old Testament to the Beginning of the New Testament. London: Religious Tract Society, 1840.

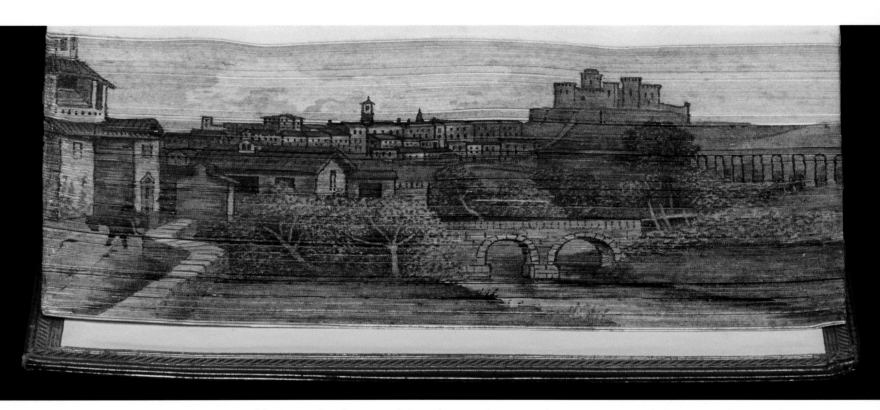

Italian landscapes adorn the fore-edges of this biography of Scipione de' Ricci (1741–1810). At the right is the Ponte delle Torri (Bridge of Towers) leading to La Rocca Albornoziana.

de Potter, Louis Joseph Antoine. *Vie de Scipion de Ricci: évêque de Pistoie et Prato.* Bruxelles: H. Tarlier, 1826. Vol. 2.

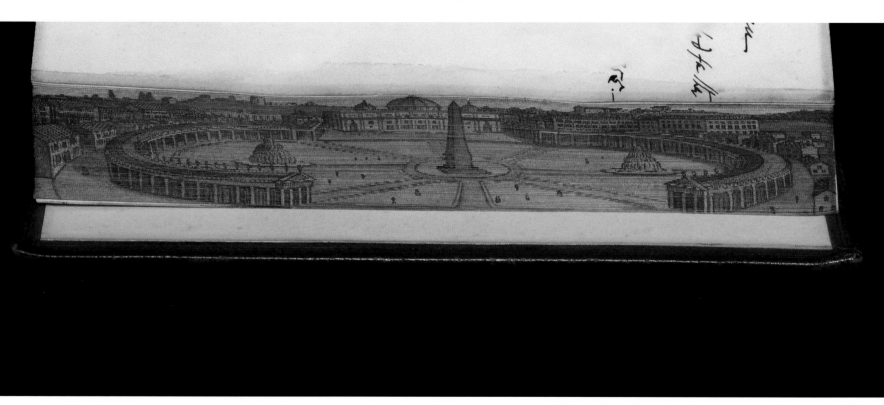

A painting of the Basilica of Saint Peter in Rome seems a well-suited subject for Babington's *Lays of Ancient Rome.*

Macaulay, Thomas Babington. *Lays of Ancient Rome: with Ivry, and the Armada.* London: Longman, Brown, Green, and Longmans, 1855.

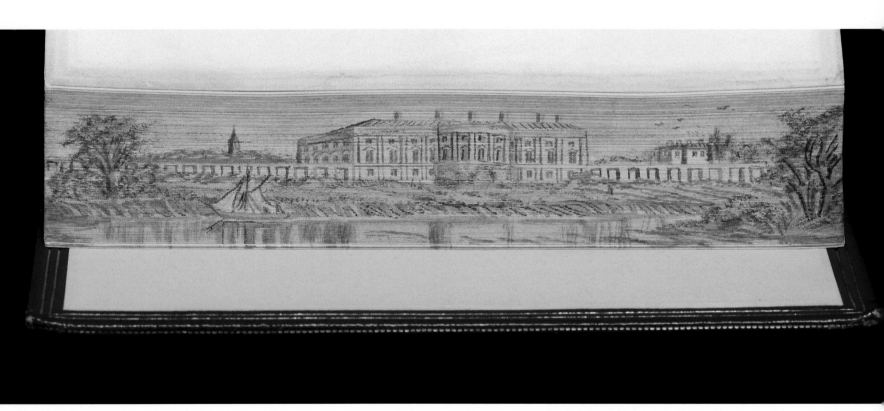

Perhaps making a statement regarding the U.S. government, the double fore-edge paintings found on this 1868 edition of Alfred Tennyson's *Idylls of the King* show the White House and a view of the Capital Building from Alexandria, Virginia.

Tennyson, Alfred. *Idylls of the King.* London: Edward Moxon & Co., 1868.

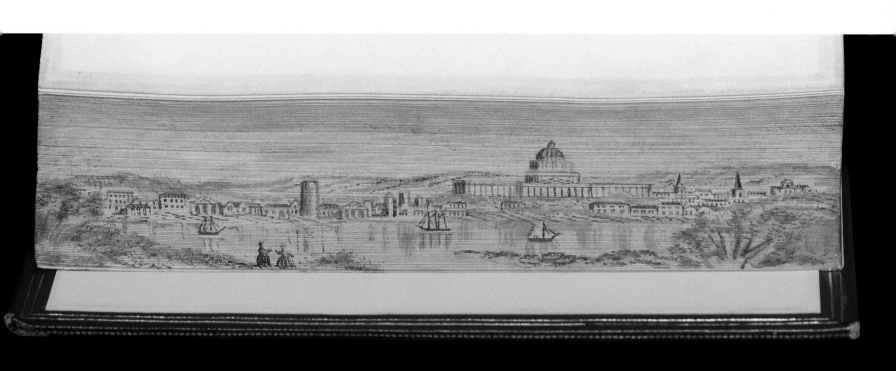

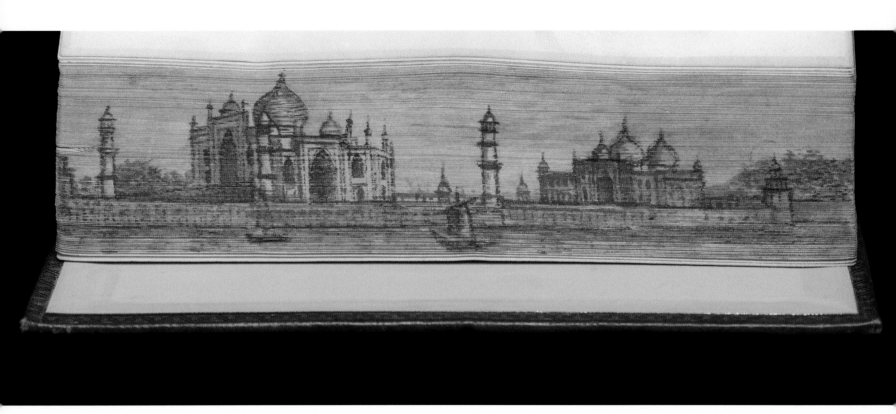

The French Missionary Evariste Régis Huc documented his travels to China and Tibet in this two-volume book. Huc intended to travel from China to India, but never made it that far. Perhaps it is fitting these volumes have fore-edge paintings of Mumbai (identified as Bombay) and the Taj Mahal (shown here).

Huc, Evariste Régis, 1813-1860. *Travels in Tartary, Thibet and China During the Years 1844-5-6*. London: Printed by Petter, Duff, and Co., [1852]. Vol. 2.

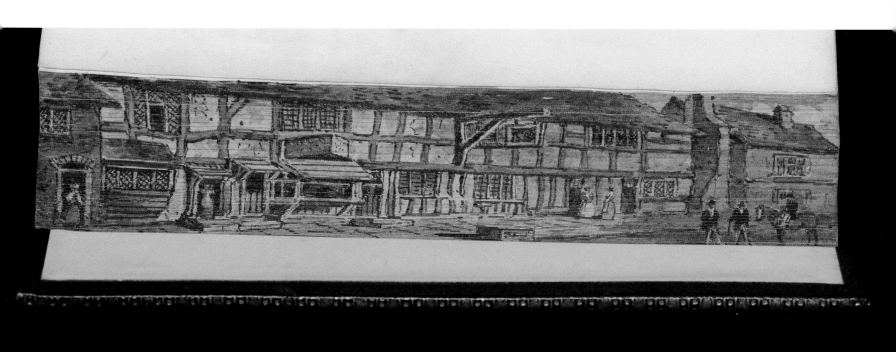

The fore-edge painting decorating this edition of Shakespeare's poems shows the house on Henley Street in Stratford-upon-Avon, England, where Shakespeare was born in 1564.

Shakespeare, William. *The Poems of William Shakspeare.* London: John W. Parker and Son, 1855.

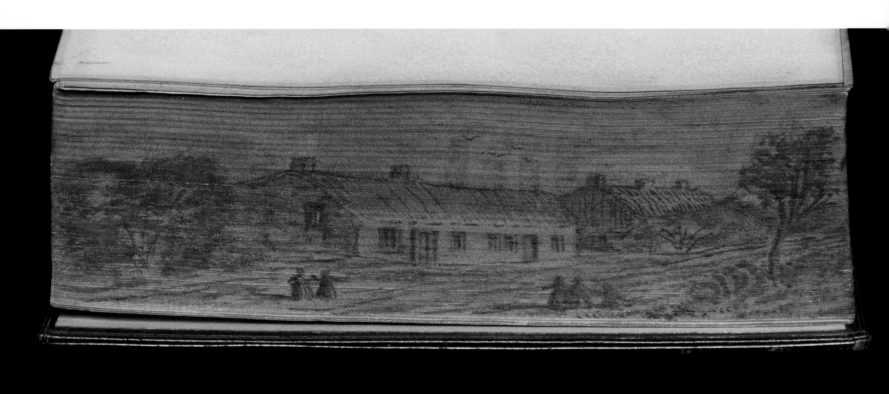

This copy of volume 1 of Robert Burns' poetry has a double fore-edge painting. Fan the pages to the right and you see the clay cottage where Burns was born in Alloway, Ayrshire, Scotland. Fan the pages to the left and you will see Struthers Steps, Kilmarnock.

Burns, Robert. *The Poetical Works of Robert Burns.* Chiswick: Printed by C. Whittingham, 1821.

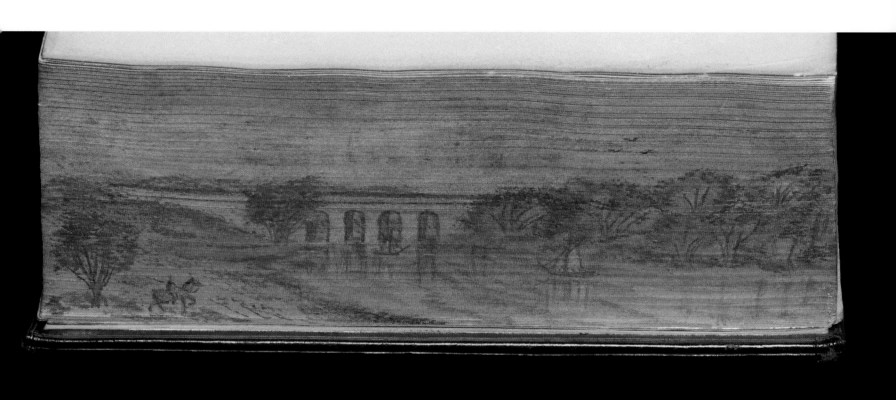

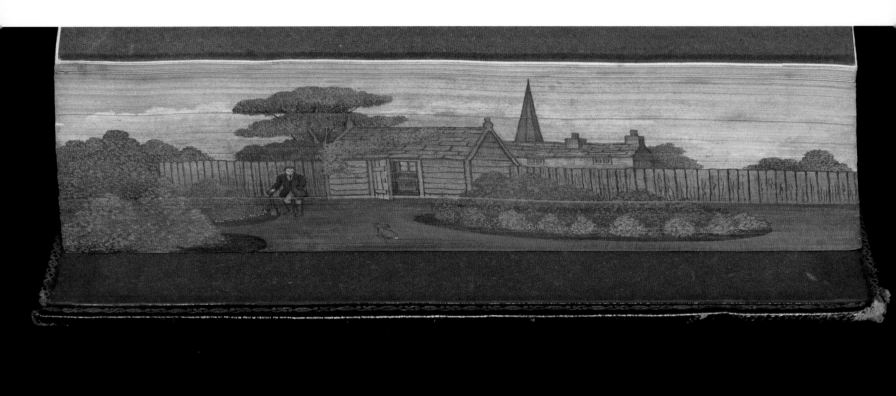

The fore-edge painting on the Cary Collection's *Poems by the Late William Cowper* show the poet at work in his garden at Orchard Side in Olney, Buckinghamshire, in the company of one of his pet rabbits, either Puss, Tiney, or Bess.

Cowper, William. *Poems by the Late William Cowper... Embellished with Engravings and a Sketch of his Life*. London: Printed by W. Lewis, published by W.H. Reid, 1820.

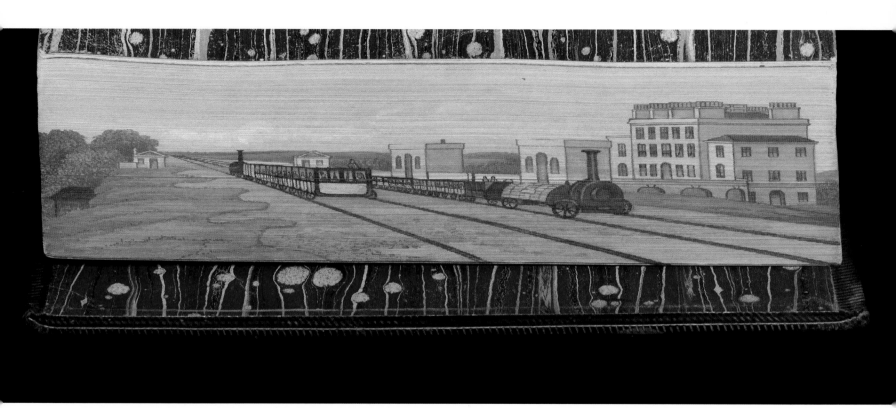

This volume devoted to railway engineers George Stephenson and his son Robert features a fore-edge painting of the Liverpool and Manchester Railway at Newton, the construction of which is described in the book.

Smiles, Samuel. *Lives of the Engineers. The Locomotive. George and Robert Stephenson.* London: John Murray, 1874.

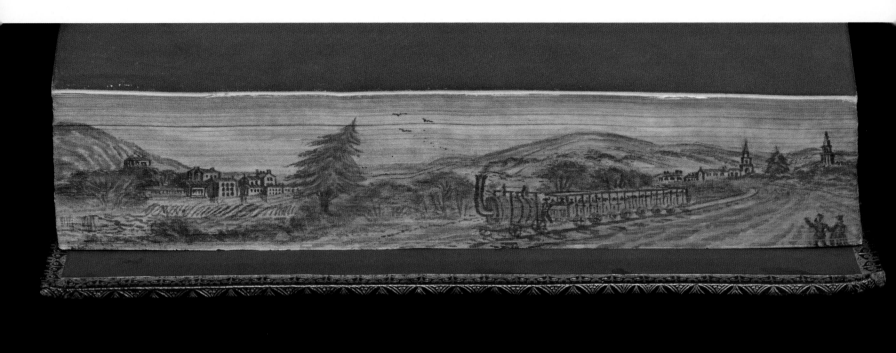

The New York railroad scene painted onto the fore-edge of this volume of poetry is based on an engraving by William H. Bartlett titled "Rail-Road Scene, Little Falls (Valley of the Mohawk)" shown on the opposite page.

The Casket, A Miscellany, Consisting of Unpublished Poems.
London: John Murray, 1829.

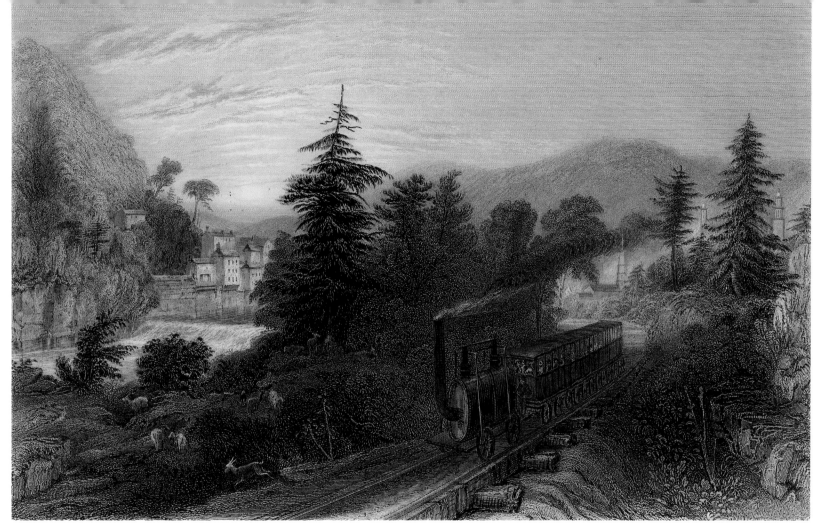

This engraving appeared in *American Scenery; or, Land, Lake and River Illustrations of Transatlantic Nature.* London: George Virtue, [1837].

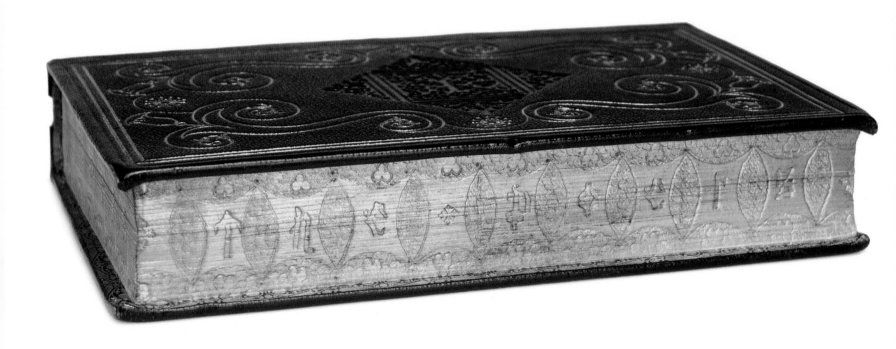

This striking gauffered fore-edge includes text announcing, "The Poets." Hidden underneath the gilt is a fore-edge painting of a fan shown on the opposite page.

The Book of the Poets. Illustrated with Forty-five Elegant Engravings on Steel. London, Darton & Co., [1848].

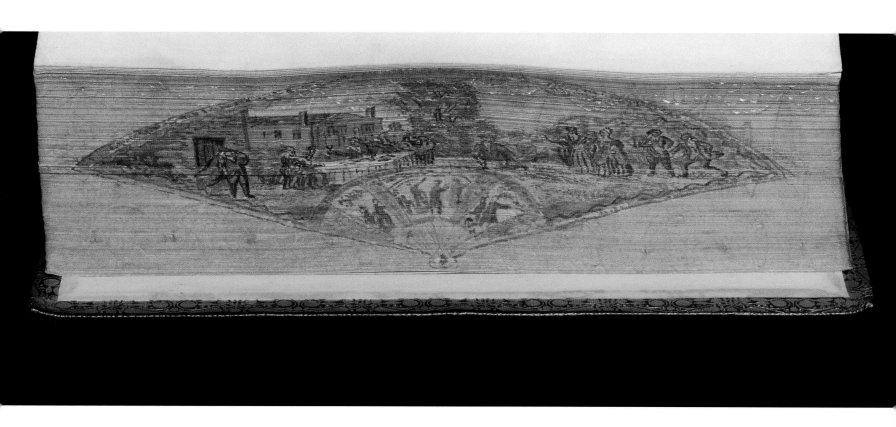

A more unconventional subject for a fore-edge painting is this fan painted in the style of the French painter Antoine Watteau (1684–1721).

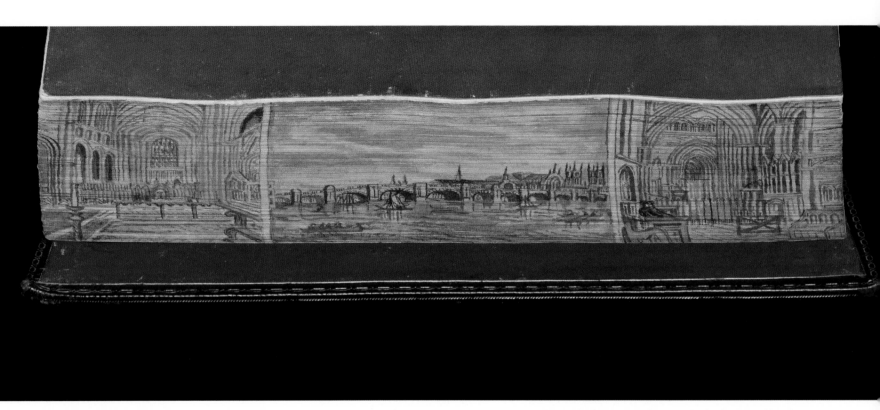

This triptych of Westminster Abbey is a suitable subject for this *Book of Common Prayer.* Shown in the three panels are: the choir and nave, a view from the Thames, and the south choir aisle.

The Book of Common Prayer ... Oxford: Printed by Thomas Baskett and Robert Baskett, Printers to the University, 1743.

FURTHER READINGS

Bennett, Jeanne. *Hidden Treasures: the History and Technique of Fore-edge Painting*. Granbury, TX: Calliope Press 2012.

Greenfield, Jane. *ABC of Bookbinding: A Unique Glossary with over 700 Illustrations for Collectors & Librarians*. New Castle, DE: Oak Knoll Press; New York: Lyons Press, 1998.

Marks, P.J.M. *The British Library Guide to Bookbinding: History and Techniques*. London: British Library, 1998.

Mitchell, John. *The Craftsman's Guide to Edge Decoration*. Five Oaks West Sussex: The Standing Press, 1993.

Nixon, Howard M. and Mirjam M. Foot. *The History of Decorated Bookbinding in England*. Oxford [England]; Clarendon Press; Oxford; New York: Oxford University Press, 1992.

Petroski, Henry. *The Book on the Bookshelf*. New York: Alfred A. Knopf: Distributed by Random House, 1999.

Pollard, Graham. *Changes in the Style of Bookbinding, 1550-1830*. [London; New York: Oxford Univ. Press], 1956.

Thornton, Dora. *The Scholar in his Study: Ownership and Experience in Renaissance Italy*. New Haven: Yale University Press, c1997.

Weber, Jeff. *Annotated Dictionary of Fore-edge Painting Artists and Binders: the Fore-edge Paintings of Miss C.B. Currie with a catalogue raisonné*. Los Angeles: Jeff Weber Rare Books, 2010.